# Bob's Your Uncle

# Bob's Your Uncle

## A Dictionary of Slang for British Mystery Fans

### Jann Turner-Lord

FITHIAN PRESS ♣ Santa Barbara, CA ♣ 1992

*Thanks to my family*
*and my best mate, Mick*

Published by Fithian Press
Post Office Box 1525
Santa Barbara, CA 93120

Library-of-Congress Cataloging-in-Publication Data:
Turner-Lord, Jann, 1947–
     Bob's your uncle : a dictionary of British slang for mystery fans
/ Jann Turner-Lord
     p.     cm.
     ISBN 1-56474-022-6
     1. Detective and mystery stories, English--Miscellanea.
   2. English language--Slang--Dictionaries. I. Title.
     PR830.D4T84   1992
427'.09--dc20                            92-3858
                                                    CIP

**I**'ve been a raging anglophile for well over thirty years. If the mystery isn't British, don't wave it in front of my nose! I currently have over three hundred British Mystery paperbacks, from Agatha Christie to Ruth Rendell, for I never could bear to toss any of my favorite writers. One of my very favorites is Jonathan Gash and his character Lovejoy, who uses more slang than I've ever seen. He was the reason I decided to write this dictionary of British slang.

I hope you have as much fun with this dictionary of slang as I had writing it. It took me two years of slogging away, but I enjoyed every minute of it. I'm a born hack, although at times I really got my knickers in a twist. But the book is strictly for fun, so have fun with it.

I dedicate this book to all the other anglophiles and dedicated British mystery readers out there like myself. Having this in print and knowing other people will enjoy it too has me over the moon!

Cheers, mates!

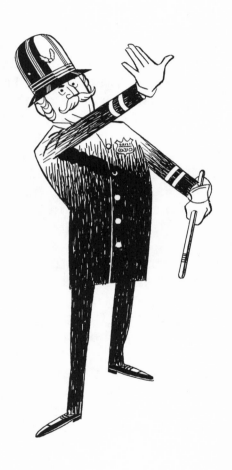

**act off his own bat**, *(v.)* doing things on his own, unauthorized. *I had nothing to do with it. He was acting off his own bat!*

**aggro**, *(n.)* aggravation. *Come quietly, mate; don't give me all of this aggro!*

**Agony Aunt**, *(n.)* advice-giving newspaper columnist (like Dear Abby).

**all mouth and no trousers**, *(adj.)* all talk and no action.

**allotment**, *(n.)* an area of land set aside for gardening, for people who live in a two up/two down with no yards.

**articulated lorry**, *(n.)* a truck with trailer.

# B

**backchat**, *(n.)* sass. *I wasn't having any backchat from a termperamental bird at this bloody stage!*

**bailiwick**, *(n.)* territory; turf (Am.). *This is my bailiwick.*

**bags (of)**, *(n.)* a lot of. *We've got bags of time!*

**bagsy**, *(v.)* to choose.

**balls-up**, *(n.)* mess; screw up. *You're irritable because last night's balls-up won't solve itself.*

**bangers**, *(n.)* sausages, with pork, bread crumbs, and spices.

**bangers and mash**, *(n.)* sausages and mashed potatoes.

**bang-up**, *(adj.)* fine; great. *You're doing a really bang-up job. Ta!*

**baps**, *(n.)* muffins.

**barm cake**, *(n.)* muffin.

**barmy**, *(adj.)* crazy; looney. *The bloody old sod was barmy.*

**barny**, *(n.)* argument; row; fight. *You should have seen it, it was a real barny!*

**beadle**, *(n.)* university official.

**beak**, *(n.)* judge; magistrate.

**beastly**, *(adj.)* awful; frightening. *It was the most beastly row.*

**bed-sitter**, *(n.)* rented room, sometimes with hot plate.

**the Beeb**, *(n.)* the BBC (British Broadcasting Corporation).

**beef tea**, *(n.)* beef bouillon.

**beefeater**, *(n.)* yeoman warder of the Tower of London.

**beer hero**, *(n.)* one whose personality changes with drink. (S.a. **whiskey muscles**.) *He was enjoying himself until a beer hero showed up at the bar ready to put a weekend shine on his opinion of himself.*

**beer and skittles**, *(n.)* good things. *Life's not all beer and skittles, mate.*

**beer mat**, *(n.)* coaster.

**(the) Belly**, *(n.)* Portobello Road (London); a district of antique shops. *His having a father who trades on the Belly meant I could get practically anything.*

**belt up**, *(v.)* shut up. *Belt up, will ya? I'm trying to have a lie-down.*

**bent**, *(adj.)* illegal. *The old soak was always doing things a bit bent.*

**bent eye**, *(n.)* sideward glance; secretive look. *The filthy old devil gave me a gappy grin through the bar hatch, but it quickly turned to consternation when I gave him the bent eye.*

**billy can**, *(n.)* milk can. *He made coffee cackhanded in a road mender's old billy can.*

**bint**, *(n.)* female companion. *Hey, mate, who's the good-looking bint waiting for you in the bar?*

**bird**, *(n.)* woman; girl. *That's my bird that bloke is with!*

**biro**, *(n.)* pen.

**biscuit tin**, *(n.)* cookie jar.

**bit of skirt**, *(n.)* woman; girl. *She's a pretty little bit of skirt!*

**bits and bobs**, *(n.)* unimportant items.

**black pudding**, *(n.)* blood sausage.

**blast!**, *(v.)* darn!; damn! *Blast it! I lost the pools!*

**bleeding**, *(adj.)* swear word (**=bloody**). *The guy was a bleeding burke!*

**blether**, *(v.)* to talk incessantly; to dither. *Mum was always blethering on.*

**blighter**, *(n.)* creep; cad; jerk. *The blighter was always dithering on!*

**blimey!**, *(excl.)* wow! *Blimey, did you see that accident?*

**bloke**, *(n.)* man; boy. *They're all here: three blokes and three birds.*

**bloody**, *(adj.)* damned. *Bloody barkers are all at it, hoping something will turn up without any proper bloody legwork.*

**bloody cheek**, *(n.)* nerve. *You have a lot of bloody cheek, coming here.*

**blow the gaff**, *(v.)* to tell on; squeal. *Enemies, I wasn't sure who mine were, but if she'd blow the gaff she was one of the worse I'd got.*

**blower**, *(n.)* telephone. *"Thanks for nothing, mate," I said, slamming the blower down.*

**Bob's your uncle**, *(excl.)* there you have it; a done thing. *We'll tell them everything, and then Bob's your uncle, you're off the hook!*

**bobby**, *(n.)* policeman. *Then Keven, our ever-vigilant bobby, caught me.*

**bodice ripper**, *(n.)* romance novel.

**boffins**, *(n.)* workers.

**bog**, *(n.)* bathroom.

**boot**, *(n.)* trunk of a car.

**boozer**,*(n.)* bar or pub. *Writers are often found reeling about the boozers arguing adverbs.*

**bonnet**, *(n.)* hood of a car.

**bonney**, *(adj.)* pretty.

**bottle out**, *(v.)* to renege; to welsh (on a deal). *We was going in on it together, but Mick bottled out!*

**bottle fog**, *(v.)* to do something difficult or impossible. *Milking the public's finer feelings is like bottling fog!*

**bounder**, *(n.)* rascal. *The bounder nicked me bike!*

**boyos**, *(n.)* boys (Welsh). *Paulie's boyos were rough blokes.*

**box**, *(n.)* television.

**braces**, *(n.)* suspenders.

**brackets**, *(n.)* parentheses.

**bread and butter pud**, *(n.)* bread pudding.

**brewer's droop**, *(n.)* impotence resulting from alcohol consumption. *After leaving the pub, he tried to get romantic, but was felled by brewer's droop.*

**brew up**, *(v.)* to make tea. *Are you brewing up, dearie? It's almost tea time.*

**bristols**, *(n.)* breasts.

**brolly**, *(n.)* umbrella. *The old dear's brolly was a lethal weapon when wielded with anger.*

**Brummie**, *(n.)* person from Birmingham.

**bubble and squeak**, *(n.)* fried leftovers (cabbage, potatoes, vegetables, etc.).

**bubble**, *(v.)* to inform on; to squeal on. *I'd strangle Dot for bubbling me with the Old Bill!*

**bugger-all**, *(n.)* little or nothing. *It came to bugger-all in the long run.*

**bugger off**, *(v.)* go away; scram. *I said to bugger off, mate, and I mean it!*

**building society**, *(n.)* bank; home loan association.

**bung**, *(v.)* put. *Bung the meat in the freezer.*

**burke**, *(n.)* jerk; dummy; fool. *A bloody forgery, you stupid burke!*

**busker**, *(n.)* street entertainer. *Each busker works his own pitch, which may have been his for decades, and more than a few proclaim themselves to be the one and only "King of the Buskers."*

**buss**, *(n.)* a kiss.

**buster**, *(n.)* breast.

**butty**, *(n.)* sandwich. *Jan had made me some cheese and tomato butties, which lasted me for about ten minutes after she was out of sight.*

# C

**cable**, *(n.)* telegram.

**cackhanded**, *(adj.)* clumsy; something mismade, done badly. *Our town council, a gaggle of real cackhanders, have tried hundreds of improvements, with the results that driving here can be hazardous to your health.*

**cadge**, *(v.)* borrow. *He's always on about other dealers cadging my experience.*

**caff**, *(n.)* greasy-spoon type restaurant. *She was still mad at me for hating her grotty caff.*

**call box**, *(n.)* phone booth.

**candle hours**, *(n.)* nighttime. *What was he doing having a run in with a cart in candle hours?*

**caravan**, *(n.)* trailer.

**carriageway**, *(n.)* highway.

**carry the can**, *(v.)* take the blame. *I don't believe this, you're asking him to carry the can for you.*

**cash-in-hand**, *(n.)* money under the table. *Part time cash-in-hand work wasn't something you mentioned to a nosy copper.*

**cellotape**, *(n.)* scotch tape.

**chalk and cheese**, *(n.)* opposites. *As different as chalk and cheese.*

**champagne ambitions and beery talent**, *(n.)* champagne tastes on a beer budget. *Your trouble is you have champagne ambitions an' only beery talent.*

**champers**, *(n.)* champagne

**chap**, *(n.)* fellow, dude. *He was a good-looking chap.*

**char**, *(n.)* cleaning lady.

**charabanc**, *(n.)* tour bus, coach. *Two charabancs were already there, their drivers having a smoke.*

**charred for**, *(v.)* cleaned for.

**chat up**, *(v.)* talk; flirt with. *There had been cases of customers being insulted, others being outrageously chatted up, others cheated on their change.*

**chemist**, *(n.)* pharmacist. *She had to go and have a prescription filled at the chemist's.*

**Chinky**, *(n.)* Chinese restaurant. *What's the bettin' you'll all wind up in an Indian or a Chinky?*

15

**chinwag**, *(n.)* chat; talk. *Come on, deary, let's have us a nice chinwag.*

**cheeky**, *(adj.)* having a lot of nerve; being a smart aleck. *Cheeky bugger! You'll be fifty yourself one day.*

**cheers**, *(excl.)* thanks; a toast. *Cheers, mate, that was nice of you.*

**cheerio**, *(excl.)* goodbye.

**cheesed off**, *(adj.)* angry. *She was really cheesed off at him for leaving her standing there.*

**chock-a-block**, *(adj.)* crowded. *Let's not go in there, it's chock-a-block!*

**get the chop**, *(v.)* to be arrested. *Did you hear? They finally caught up with him and he got the chop!*

**chop shop**, *(n.)* Chinese restaurant.

**chuffed**, *(adj.)* happy; pleased. *I am really chuffed, I got my book published!*

**C.I.D.**, *(n.)* Criminal Investigation Department.

**clink**, *(v.)* send to jail.

**clobber**, *(n.)* clothes; belongings. *She was openly checking out the other birds to make sure her clobber wasn't being bettered—or worse, copied—by some enemy.*

**clocked**, *(adj.)* hit; knocked down. *Yeah, he smarted off one too many times and got himself clocked.*

**clotted cream**, *(n.)* a sweet, thick dessert cream.

**coals to Newcastle**, *(expr.)* a fruitless endeavor [coal comes from Newcastle]. *Trying to sell ice to an Eskimo is like selling coals to Newcastle.*

**cob**, *(n.)* muffin or roll.

**cobber**, *(n.)* fondness. *He took an instant cobber to her.*

**cobble**, *(v.)* fix; put together.

**cock-a-hoop**, *(adj.)* confused; lost. *After the knock on the head, he was all cock-a-hoop.*

**cock of the walk**, *(n.)* conceited person. *Now that she has that fancy bloke, she thinks she's the cock of the walk.*

**cock-up**, *(n.)* a mess; a bad job. *That was the last straw; he really did a cock-up this time.*

**cockalorum**, *(n.)* affectionate appellation.

**cock shout**, *(n.)* dawn. *Dance and booze the night away, then you stagger to your pit at cock shout.*

**Cockney**, *(n.)* traditionally a person born within the sound of Bows bells, St. Mary le Bow, in Cheapside, in the heart of the city of London; now considered the east-end working class.

**Cockney rhyming slang**, form of wordplay favored by Cockneys, in which an intended word is replaced by a pair of words, the second of which rhymes with the intended word; often abbreviated to the first, or non-rhyming, word of a pair only, as indicated in parentheses.

**pig's ear**, beer.

**elephant's trunk**, drunk.

**half inch**, pinch (steal).

**butcher's hook** (or **butcher's**), look. *Did you get a good butcher's at that ring?*

**china plate**, mate (friend). *How's me old china plate?*

**loaf of bread**, head.

**Mutt and Jeff**, deaf.

**pen and ink**, stink.

**pride and joy**, boy.

**east and west**, breast.

**bolt the door**, whore.

**horse and carts**, darts.

**Mickey Mouse**, house.

**Noah's ark**, narc (informer).

**barnet fair**, hair.

**apples and pears**, stairs.

**bees and honey**, money.

**mince pies** (or **mincers**), eyes. *You have a lovely set of mincers.*

**gold watch**, scotch.

**Oscar Wilde** (or **Oscar**), mild.

**Gary Glitter** (or **a Gary**), bitter.

**Mick Jagger**, lager. *A half of Mick.*

**snake and pygmy**, steak and kidney.

**ham shank**, Yank.

**laugh and titter**, bitter.

**jam jar**, car.

**boat race**, face.

**Oliver Twist** (or **Olivered**), pissed.

**rosy lea**, tea.

**pots and pans** (or **pots**), vans. *We'd need three pots at least for this haul.*

**Hampstead heath**, teeth.

**Adam and Eve**, believe. *Would you Adam and Eve it?*

**cob a coal**, the dole.

**trouble and strife**, wife. *Hey, mate, having a time with the old trouble and strife again?*

**ginger beer**, queer.

**whistle and flute**, suit.

**Caine and Abel**, table.

**tit for tat** (or **tifter**), hat.

**turtle doves** (or **turtles**), gloves.

**daisy roots** (or **daisies**), boots.

**in the rude**, nude.

**holy friar**, liar.

**trick cyclist**, psychiatrist.

**Sweeney Todd**, flying squad.

**codswallop**, *(n.)* rubbish; a lie. *How could you believe that? It's a load of codswallop.*

**collywobbles**, *(n.)* creeps; shakes. *She really had the collywobbles after that fright.*

**come over queer**, *(v.)* to feel ill or agitated. *You silly sod, you made me come over queer, what are you doing here?*

**come up trumps**, *(v.)* come out smelling like a rose. *No matter what happened in his life, he always did come up trumps.*

**coo**, *(excl.)* wow! *Coo! That's a really sweet new motor, mate.*

**cooler**, *(n.)* prison.

**constable**, *(n.)* policeman.

**cop shop**, *(n.)* police station. *They've collared one yobo at the cop shop.*

**copper**, *(n.)* policeman. *The most obnoxious sight in the world, a copper enjoying an illicit pint, whooping it up on our taxes!*

**corf**, *(n.)* mining car.

**corker**, *(n.)* oner; a real dust-up. *Blimey, that was a real corker.*

**cosh**, *(v.)* strike. *Some bloke came up from behind and coshed him on the head.*

**cot death**, *(n.)* crib death; S.I.D.S.

**cottage pie**, *(n.)* dish with hamburger and potatoes; like shepherds pie without lamb.

**council houses**, *(n.)* state-owned homes.

**council pit**, *(n.)* local garbage dump.

**council rates**, *(n.)* taxes.

**courgette**, *(n.)* zucchini.

**cream tea**, *(n.)* a light meal of tea, scones, clotted cream, and jam.

**crikey**, *(excl.)* darn; expression of surprise. *Crikey, mate, you spilled the whole thing!*

**crisps**, *(n.)* potato chips.

**crumpet**, *(n.)* breakfast muffin; slang for girl.

**cups**, *(n.)* drunk. *He's in his cups.*

**custom**, *(n.)* business. *The publican had built up a good custom at his pub.*

# D

**dab hand**, *(n.)* deft person. *She's a dab hand with a needle and thread.*

**daft**, *(adj.)* crazy; looney. *Ever heard of anything so daft? You couldn't invent a loonier law if you tried!*

**dead cert**, *(n.)* a certainty. *That's a dead cert, me old son.*

**dearth**, *(n.)* lack. *Dearth of constables.*

**deco**, *(n.)* look. *Did you get a deco at that?*

**deep lumber**, *(n.)* severe trouble.

**D.I.Y. store**, *(n.)* do-it-yourself store.

**dicey**, *(adj.)* chancy; uncertain. *The venture was a bit dicey.*

**dickey bow**, *(n.)* bow tie.

**digs**, *(n.)* rooms; apartment; flat. *The digs weren't grand but they'd have to do for now.*

**dip**, *(n.)* pickpocket.

**dinkies**, *(n.)* toy cars.

**dish up**, *(v.)* serve a meal. *Come to the table; your mum's just dishin' up!*

**dishy**, *(adj.)* good-looking. *She was a real dishy-looking bird for a librarian.*

**divan bed**, *(n.)* sofa bed.

**dock**, *(n.)* court. *He knew if he wasn't careful he'd end up in the dock just like Jocko.*

**dodgy**, *(adj.)* risky, disreputable. *Anyone who actually tried to welsh on a loan could wind up with dodgy kneecaps.*

**doff**, *(v.)* take off. *He doffed his hat.*

**do porridge**, *(v.)* serve time in prison. *What's the matter, you look pale; been doing porridge?*

**dole**, *(n.)* welfare.

**do a bunk**, *(v.)* to run away. *Yes constable, he's done a bunk, been gone a week!*

**donkey jacket**, *(n.)* heavy work coat with leather elbows.

**don't give a monkey's**, *(v.)* don't care; don't give a toss. *Didn't you hear me? I said I don't give a monkey's!*

**doss**, *(v.)* stay; live; reside. *When they asked him where he was living, he told them he was dossing down temporarily at a mate's place.*

**dosser**, *(n.)* homeless or jobless person.

**dosshouse**, *(n.)* flophouse; cheap hotel; abandoned house. *The rest are used as doss houses by anybody as takes a fancy.*

**down to**, *(adj.)* up to; to the blame of. *It's not his fault, I tell you. It's down to me.*

**draughts**, *(n.)* checkers.

**drawing pin**, *(n.)* thumb tack.

**dross**, *(n.)* garbage; junk. *The so-called antique dealer had nothing but a bunch of dross.*

**dry stick**, *(n.)* humorless person. *You're turning into a right dry stick.*

**duckegg**, *(n.)* patsy. *Like I said, he was a born duckegg!*

**duff up**, *(v.)* beat up. *When they found him, he had been duffed up something fierce.*

**dummy**, *(n.)* baby's pacifier.

**dust-up**, *(n.)* fight. *The boys had a bit of a dust-up, that's all.*

**dust bin**, *(n.)* garbage can.

**dustbin man**, *(n.)* garbage man.

# E

**earlies**, *(n.)* early shift (at work).

**Eccles cake**, *(n.)* puff pastry with fruit and raisins.

**eel out**, *(v.)* slip away. *I decided to save my breath instead and eeled out among the crowd.*

**egg and chips**, *(n.)* eggs and french fries.

**egg soldiers**, *(n.)* toast cut in strips for dipping in egg yolk. *She had five little egg soldiers all lined up on her plate.*

**Egon Ronat**, *(n.)* a famous restaurant guide.

**electric fire**, *(n.)* space heater.

**elevenses**, *(n.)* mid-morning tea or coffee break.

**estate agent**, *(n.)* real estate agent.

# F

**facer**, *(n.)* problem. *That's a real facer alright.*

**fag**, *(n.)* cigarette. *Dealers tapping on the table, watching through the fag smoke with crinkled eyes.*

**fairy cake**, *(n.)* cupcake.

**feel a right lemon**, *(v.)* feel a fool. *She could always make me feel a right lemon.*

**feel rough**, *(v.)* feel ill or agitated. *You admitted a minute ago you're feelin' rough. What's up?*

**fall off the back of a lorry**, *(v.; expr.)* facetious expression for a stolen article. *Now, Arthur, you're sure this didn't fall off the back of a lorry?*

**festering**, *(adj.)* same as **bloody**.

**fete**, *(n.)* fair. *I'm sick of fetes, pageants, displays. We have an epidemic of them every summer!*

**fishfingers**, *(n.)* fish sticks.

**fiddle**, *(n.)* illicit deal. *On the fiddle.*

**flaming**, *(adj.)* same as **bloody**. *They were having a flaming loud row.*

**flash**, *(adj.)* above oneself. *Aren't we acting a bit flash lately?*

**Flash Harry**, *(n.)* a dandy. *He thought himself a real Flash Harry.*

**flat**, *(n.)* apartment; rooms.

**flipping**, *(adj.)* same as **bloody**.

**flog**, *(v.)* sell. *I decided to flog it for twice what she could.*

**flummox**, *(v.)* fool; trick. *I'd been flummoxed, alright, and easy as a baby.*

**flush**, *(adj.)* having money. *He'd just gotten his pay packet and was feeling flush.*

**flying squad**, *(n.)* police services.

**footpad**,*(n.)* robber; highwayman.

**foot slogging**, *(n.)* hard walking. *It was a good ten miles over the moors and would take some real foot slogging.*

**forelock-tugging**, *(n.)* brown-nosing. *A little forelock-tugging never went amiss.*

**fortnight**, *(n.)* two weeks.

**fow**, *(adj.)* ugly. *He'd never seen anything more fow than a cackhanded fake antique.*

**frog in fruit**, *(n.)* something that doesn't fit. *Finding him among a mob of peace-loving pro-earth protesters is like a frog in fruit.*

**Froggie**, *(n.)* Frenchman.

**fruit machine,**
(*n.*) slot machine.

**fry-up,** (*n.*) fried
sausage and
potatoes or eggs
and bacon. *Ian's
fry-up is enough
to turn the
strongest
stomach. Imagine
four charred sausages next to a wobbly egg's
uncooked eye staring up at you all
reproachful from shame at its plight.*

**fug,** (*n.*) foul, smoky air. *The dense fug in Ian's
caff starts corrosion where acid rain leaves
off.*

**full stop,** (*n.*) period.

**full whack,** (*n.*) full price; retail price. *I'm not
paying full whack for a telly, any day!*

**fur coat and no knickers,** (*n.*) person who
thinks himself better than his peers. *She
fancies herself better than others, but to me
she's still a fur coat and no knickers.*

# G

**gaff**, *(n.)* house; apartment; place of work.

**gaol**, *(n.)* jail.

**gas and gaiters**, *(adj.)* fine and dandy. *It might seem like an easy job, but it's not all gas and gaiters!*

**gaudies**, *(n.)* dressy clothes. *"Like me gaudies?" he said. The old devil had shaved, nearly, and had a red carnation in his filthy beret.*

**gawp**, *(v.)* look. *I felt so daft on my own, but Lucy, our choir mistress, was in, so I wasn't stuck for something to gawp at.*

**geezer**, *(n.)* bloke.

**gentry**, *(n.)* titled upper class.

**gelt**, *(n.)* money.

**Geordy**, *(n.)* person from Newcastle.

**get knotted**, *(v.)* shut up. *Get knotted, you silly burke!*

**get shut of**, *(v.)* get rid of. *We have to get shut of this bloke before he drives me barmy!*

**get up one's nose**, *(v.)* bother one; make one angry.

**git**, *(n.)* stupid person. *You daft git!*

**give a bell**, *(v.)* call on the telephone. *Ta. Tell him to give me a bell.*

**give the elbow**, *(v.)* get rid of (a person). *They gave him the elbow right out of the pub!*

**glad rags**, *(n.)* good clothes.

**glims**, *(n.)* lights. *She had her glims on to let me know she was home.*

**gob**, *(n.)* mouth; *(v.)* spit.

**gooseberry**, *(n.)* third person in the company of two.

**gormless**, *(adj.)* thoughtless; useless. *I'm gormless with money and women, which is why I'm always broke.*

**grass**, *(v.)* inform; betray. *The sod would grass on his own mate!*

**groat**, *(n.)* money; change.

**grotty**, *(adj.)* dirty; broken down. *Irish nosh bars are as grotty as ours any day. We found one in a side street, full of guitar-laden posters and stained tables.*

**grouse**, *(v.)* complain. *Quit grousing and give me an 'and!*

**gruel**, *(n.)* porridge; oatmeal; mush.

**guff**, *(adj.)* worthless, trouble.

**gungey**, *(adj.)* garbage; dirt. *It is truly rural, as house agents say, meaning cheap and gungey.*

**Guy Fawkes Day (Bonfire Night)**, November 5. In 1605 Guy Fawkes and compatriots tried to assassinate the king and the assembled Parliament in retaliation for increasing repression of Roman Catholics in England. On November 5, children make a Guy (dummy) and ask people for money; with the money they purchase firecrackers, and then throw the Guy on a bonfire at the end of the night.

**Gyppo**, *(n.)* Gypsy.

# H

**hack**, *(n.)* writer.

**half cut**, *(adj.)* half drunk.

**hammer and tongs**, *(adv.)* doing a thing with feeling, especially fighting. *The two blokes were going at it hammer and tongs.*

**haversack**, *(n.)* backpack.

**headlamp**, *(n.)* headlight.

**High Street**, *(n.)* Main Street.

**high tea**, *(n.)* tea and cakes, maybe sandwiches, served at 4:00.

**hire purchase**, *(n, v.)* rent to own. *Hire purchase was out of course; they didn't have the credentials to satisfy the terms of any HP contract.*

**hoarding**, *(n.)* billboard.

**hobnails**, *(n.)* work boots.

**hold-all**, *(n.)* overnight bag.

**hols**, *(n.)* holidays. *When are you takin' your hols this year, deary?*

**homely**, *(adj.)* homey; cozy.

**hook the Hoover to the mains**, *(v.)* plug in.

**Hooray Henry**, *(n.)* snob. *At 8:30 a plum-voiced Hooray Henry knocked at my door.*

**hop it**, *(v.)* leave. *Now hop it. If Mum catches you 'ere it's trouble.*

**hop the wag**, *(v.)* give up alcohol.

**hove in on**, *(v.)* move in on. *Before I knew it she had hoved in on me.*

**hoy**, *(excl.)* exclamation used to attract attention.

# I, J

**ice lolly**, *(n.)* popsicle.
**indicator**, *(n.)* turn signal.
**Inland Revenue**, *(n.)* British tax agency;
    equivalent of American I.R.S.
**jack it in**, *(v.)* give up; throw in the towel. *I'd
    had enough. I was ready to jack it in.*
**Jack the Lad**, *(n.)* partier; womanizer; Good
    Time Charlie (Am.). *He was a real Jack the
    Lad when it came to partying.*
**jelly babies**, *(n.)* candy similar to gummy bears.
**Jock**, *(n.)* Scotsman.
**John Thomas**, *(n.)* a man's private parts.
**Jolly Jack**, *(n.)* sailor. *Like all Nell's dates, he
    was a Jolly Jack from a ship at our town's
    port.*
**juggernaut**, *(n.)* large truck; semi (Am.).
**jumble sale**, *(n.)* garage sale; flea market. Also
    **bring and buy**.
**jumper**, *(n.)* sweater.

# K

**kip**, *(v.)* sleep. *Missy was kipping in her basket, didn't even notice me return, selfish sod. I wish all females were like her.*

**kiosk**, *(n.)* ticket booth or newspaper stand.

**kitted out**, *(adj.)* supplied; equipped. *He was totally kitted out for his safari.*

**knackered**, *(adj.)* worn out; tired. *Badly knackered though I was, sleep was long coming.*

**knicker**, *(n.)* pound sterling.

**knickers**, *(n.)* women's panties or boy's short pants.

**knickers in a twist**, *(expr.)* uptight. *Don't get your knickers in a twist, love!*

**knock back**, *(n.)* setback; an upset in plans. *Well, it has been a sort of a knock back, hasn't it?*

**knock up**, *(v.)* call on someone. *Shall I knock you up about eightish then?*

**knock off**, *(v.)* steal. *You've been floggin' perfect goods. Knocked off tellys an' trannies at knock-down prices!*

**knocking shop**, *(n.)* house of prostitution.

**knuckledusters**, *(n.)* brass knuckles; *(adj.)* angry. *He glanced behind me at his older son, all knuckledusters. "Put them bloody things away, you stupid burke!"*

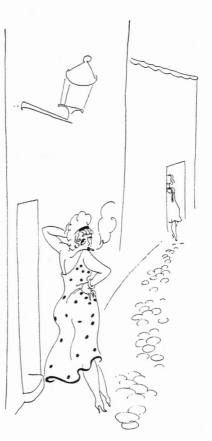

# L

**lad-pack,** *(n.)* group of young men on a fashionable bent. *He likes the ladies but prefers to travel in lad-packs.*

**lag,** *(n.)* prisoner. *He bombarded an old lag he'd met inside Oxford Prison with repeated demands.*

**lam off,** *(v.)* leave; take flight. *That bird just lammed off at the mention of your name!*

**lark,** *(n.)* fun time. *We was just having a bit of a lark, guvner!*

**layabout,** *(n.)* lazy person. *That lad is just a layabout, in my opinion.*

**layby,** *(n.)* roadside rest area. *A police car in a layby watched me go by.*

**lead,** *(n.)* leash.

**leave out,** *(v.)* cut it out; forget it. *"Leave it out,"* Keven said. *"I was took in by the geezer that flogged me the stuff."*

**leet**, *(n.)* English law court.

**learner's plates**, *(n.)* learner's automobile license plates. Also **l-plates**.

**leg it**, *(v.)* run away. *You'd better leg it, the old bill is looking for you!*

**lie-down**, *(n.)* nap. *Don't disturb me now, I'm having a bit of a lie-down.*

**lift**, *(n.)* elevator.

**do a lift**, *(v.)* commit a robbery. *He was caught doing a lift and got clinked.*

**Limey**, *(n.)* Englishman.

**lino**, *(n.)* linoleum.

**loaf**, *(n.)* brain. *Use your loaf!*

**local**, *(n.)* neighborhood pub.

**lodger**, *(n.)* renter.

**lollipop lady**, *(n.)* crossing guard with stop sign.

**lolly**, *(n.)* money. *Look after yourself while I'm in the nick. Lucy will see you get your lolly.*

**loo**, *(n.)* restroom. *She'd been complainin' about the outside loo not working, an' finally they had a look an' decided the damage was down to her.*

**lorry**, *(n.)* truck.

**lose one's rag**, *(v.)* lose one's temper. *It's no wonder you lose your rag. Even a patient bloke like me would.*

**lucre**, *(n.)* money.

# M

**mac**, *(n.)* raincoat.

**maisonette**, *(n.)* a flat with balcony.

**Mancunian**, *(n.)* person from Manchester.

**mangle**, *(n.)* laundry wringer.

**mankey**, *(adj.)* shabby; poorly made; rotten (of food). *He knew if he made the fake too mankey it'd never pass.*

**Marmite**, *(n.)* yeast extraction, eaten on toast (as Australian Vegamite).

**marrows**, *(n.)* squash.

**mash**, *(n.)* mashed potatoes; to steep tea.

**mate**, *(n.)* friend. *They were the best mates a bloke could ask for.*

**mess of pottage on his platter**, *(n.)* enough to deal with; a handful. *Don't bother him with that; he already has a mess of pottage on his platter.*

**mews**, *(n.)* courtyard or square with houses and old stables.

**milkman's float**, *(n.)* milk truck.

**minced meat**, *(n.)* ground beef.

**mixed grill**, *(n.)* platter of grilled food: sausages, chops, grilled tomatoes, etc.

**moggie**, *(n.)* cat. *I'd never owned a moggie. Missy was my first.*

**moniker**, *(n.)* signature.

**More tea, Vicar?**, *(expr.)* a polite aside to cover an embarrassing moment.

**morris**, *(n.)* English dance.

**M.O.T.**, *(n.)* Ministry of Transport; annually tests all cars for road-worthiness.

**be Mother**, *(v.)* act as hostess. *She was never any good at being Mother at tea parties.*

**mountebank**, *(n.)* cad; scoundrel.

**mouth on**, *(v.)* inform on; squeal on. *He saw the inspector coming up the drive and knew he'd been mouthed on.*

**muck sweat**, *(n.)* nervousness. *He's in a muck sweat.*

**muck up**, *(v.)* to foul up. *It wasn't my fault I'd mucked up their neffie program.*

**muck about**, *(v.)* mess around; hang out. *'Ere, 'ere! Quit all that mucking about in me shop.*

**mummer**, *(n.)* person dressed for a costume party.

# N

**naff**, *(adj.)* no good.

**naff off**, *(v., excl.)* get lost.

**nana**, *(n.)* fool. *I felt like a right nana.*

**nappies**, *(n.)* diapers.

**nark**, *(v.)* to anger. *Sometimes women really nark me; no sense of priorities.*

**National Service**, *(n.)* military service, performed by all young men since World War II. *They'd been boyhood pals and even done their National Service together.*

**natter**, *(n.)* chat; cozy talk. *I was really looking forward to havin' a natter with Lucy.*

**naughts and crosses**, *(n.)* tic-tac-toe.

**neck and crop**, *(adv.)* with everything; entirely. *She threw him out neck and crop.*

**neffie**, *(adj.)* no good; iffy. *I wouldn't go to church with you, let alone your neffie clink!*

**nerk**, *(n.)* idiot; jerk. *Albert Worthington is a nerk; even other nerks think he's a nerk.*

**nettled**, *(adj.)* angry.

**Newgate fringe**, *(n.)* prison haircut.

**nick**, *(v.)* steal; arrest. **nicked**, *(adj.)* stolen;. **the nick**, *(n.)* jail. *He was probably the fastest resprayer of nicked motors in the east.*

**niff**, *(n.)* smell. *Everyone let Tinker have a wide berth after getting one niff of him.*

**niggle**, *(v.)* bother; stop.

**nipper**, *(n.)* child.

**nobble**, *(v.)* beat up; inform on.

**nob**, *(n.)* upper class person; bigwig.

**nosh**, *(n.)* food; *(v.)* eat.

**nosh bar**, *(n.)* restaurant; cafe. *There's always a well-worn pub and a sleazy nosh bar within spitting distance of any auction.*

**nought**, *(n.)* nothing.

# O

**off-license**, *(v.)* stop selling alcohol.

**off-putting**, *(adj.)* offensive. *The manner in which she spoke was very off-putting.*

**off the peg**, *(adj.)* off the rack.

**old barley**, *(n.)* Scotch; hard liquor.

**old Bill**, *(n.)* police. *If the old Bill hauls me off, you know what to do.*

**old flannel**, *(n.)* butter-up job. *Coo, she really gave you the old flannel!*

**old soak**, *(n.)* alcoholic. *His croak saved me. In your bleedin' right 'and pocket. I could feel the animosity vibing from the ladies toward the*

*old soak for his language.*

**old trout**, *(n.)* term of affection; also: **old bean**, **old sweat**.

**on the cheap**, *(adv.)* inexpensively; cheaply. *He was always broke and living on the cheap.*

**on the fiddle**, *(adv.)* on the take; crooked. *It wouldn't be the first time a copper went on the fiddle!*

**on the game**, *(adj.)* on the make. *She didn't want to sit on her own, because that always hinted at the likelihood of a woman being on the game.*

**on the mend**, *(v.)* getting better.

**on yer bike!**, *(excl.)* go away! *"You think you make me feel threatened?" He jerked a thumb at the gate. "On yer bike, before I show you what tough is!"*

**one-off**, *(adj.)* once in a lifetime; unique. *Don't expect this to happen again. This is a one-off situation.*

**over the moon**, *(adj.)* delighted; happy. *He'd be over the moon if you two would give him an 'and.*

# P

**P.A.**, *(n.)* personal assistant; secretary.

**packets**, *(n.)* lots; much. *They had packets of money.*

**Paddy**, *(n.)* Irishman.

**parp**, *(v.)* fart. *The baby parped and whistled. God knew what she fed him; he sounded like a sink constantly emptying.*

**pastie**, *(n.)* meat pie.

**pastille**, *(n.)* throat lozenge; fruit candy.

**patch**, *(n.)* territory; turf. *This was Barney's patch, and he knew he shouldn't be here.*

**P.C.**, *(n.)* police constable.

**Place of Safety Order**, *(n.)* child endangerment law taking children from abusive parents.

**pea-souper**, *(n.)* heavy fog.

**peaky**, *(adj.)* pale, unhleathy.

**peckish**, *(adj.)* hungry. *You couldn't run to another pasty, could you love? I'm a bit peckish.*

**peeler**, *(n.)* policeman.
**perambulator, pram**, *(n.)* baby carriage.
**petrol**, *(n.)* gasoline. *This wasn't the time to run out of petrol, right in front of a cop shop.*
**petrol tin**, *(n.)* gas can.
**pie shop**, *(n.)* bakery.
**pike**, *(v.)* trudge. *He knew he had to pike on or he wouldn't make it.*
**pikey**, *(n.)* Gypsy trader.
**pillar box**, *(n.)* mail box.
**pillock**, *(n.)* jerk; nerd.
**piss all**, *(n.)* nothing. *Magistrates know piss all about crafty, sweet-talkin' little villains that can worm their way out of anything.*
**piss artist**, *(n.)* drunk; late-night carouser.
**piss off**, *(v.)* get lost.
**pissed**, *(adj.)* drunken.
**pitchy**, *(adj.)* dark. *It was so pitchy I couldn't see my hand in front of my face.*
**plain as a pikestaff**, *(adj.)* plain as day. *It was plain as a pikestaff that there wouldn't be any more work done today.*
**plimsolls**, *(n.)* rubber-soled slip-on shoes.
**plod**, *(n.)* policeman. *Now that we know what the plods are doing up in Hampshire, we can proceed.*
**plonk**, *(v.)* put. *You've got to be senseless to plonk it in the middle of the road like you did.*
**plonky**, *(adj.)* unfamiliar.

**ploughman's lunch**, *(n.)* cheese, Branston pickle (chutney) and bread, sometimes with tomato and apple.

**podgy**, *(adj.)* chubby; plump.

**ponce**, *(n.)* homosexual. *Turned up dolled like a pair of ponces, all rings and hair oil.*

**pong**, *(n.)* smell; bad odor. *I became conscious of an atrocious yet familiar pong.*

**poof(ter)**, *(n.)* homosexual.

**Poppet**, *(n.)* affectionate nickname.

**posh**, *(adj.)* ritzy. *He had taken off one of his mittens to reveal the poshness of the occasion. Otherwise he was as grubby as ever.* **posh frock**, *(n.)* fancy clothes.

**poxy**, *(adj.)* no good; inferior. *A poxy slum on the seafront.*

**pram top**, *(n.)* convertible top of an automobile.

**premium bonds**, *(n.)* post office lottery tickets.

**pub**, *(n.)* bar; lounge.

**pub-crawl**, *(n.)* bar-hopping expedition.

**public call box**, *(n.)* telephone booth.

**publican**, *(n.)* pub owner.

**pull one's bird**, *(v.)* steal one's girl.

**pull one's whack**, *(v.)* do one's part or job.

**pumps**, *(n.)* canvas tennis shoes.

**punter**, *(n.)* customer. *I'm the reason half the punters come in this 'ere pub!*

**push chair**, *(n.)* stroller.

**push off**, *(v.)* get lost. *Push off, Keven!*

**Queen's English**, *(n.)* very proper English spoken with an upperclass accent.

**Queen's evidence**, *(n.)* evidence given in a court of law.

**queue**, *(n., v.)* waiting line; to wait in line. *When I finally crack, it'll be queuing at the checkout, where the till girl runs out of change and the queue's exasperated because you're holding everybody up, and you've paid nearly a quid for one measly rotten lettuce!*

**quid**, *(n.)* pound sterling.

# R

**Rabbit on**, *(v.)* talk too much. *Quit rabbiting on, girl!*

**rag**, *(n.)* joke; *(v.)* to make a practical joke. *You don't want too many people in on a rag.*

**rag and bone man**, *(n.)* junk man. *Even a rag and bone man wouldn't pick up the dross put out in that place.*

**rag-taggle**, *(adj.)* raggedy. *They were the worst bunch of rag-taggle nippers I'd ever seen.*

**rasher**, *(n.)* slice of bacon.

**rave-up**, *(n.)* party; good time. *It was an all-night rave-up.*

**readies**, *(n.)* money.

**make redundant**, *(v.)* lay off.

**redundancy pay**, *(n.)* severance pay.

**registered minder**, *(n.)* child care worker or baby sitter.

**registration plate**, *(n.)* license plate of an automobile.

**righto**, *(excl.)* alright; okay. *Righto! I'm off, then, Mrs. H. Keep in touch.*

**rot**, *(n.)* garbage. *What a load of rot!*

**round the twist**, *(adj.)* crazy. *The old lady was a little round the twist these days.*

**row**, *(n.)* argument. *She was sorry they'd had the row; she felt bad now.*

**rozzer**, *(n.)* policeman.

**rubber**, *(n.)* eraser.

**ruddy**, *(adj.)* same as **bloody**.

**rum one**, *(n.)* audacious person. *God save us, you're a rum one, and no mistake.*

**rumble**, *(n.)* news; gossip. *The rumble going around was that he'd been nicked.*

**do a runner**, *(v.)* run away. *You say you've got a bad feelin' about doin' a runner, but that's what you should do, piss off, fast!*

# S

**S.A.S.**, *(n.)* Special Air Service.

**sag off**, *(v.)* play hooky.

**sailor's elbow**, *(n.)* the bum's rush. *"The Major's left," she said; her tone told me he'd got the sailor's elbow.*

**Sally Army**, *(n.)* Salvation Army.

**sarky**, *(adj.)* sarcastic. *I've had enough of your sarcy comments for one day!*

**scagged**, *(adj.)* cut; slashed.

**scarper**, *(v.)* run off; escape.

**scones**, *(n.)* pastry, sometimes raisin-filled, taken at afternoon tea.

**Scotch eggs**, *(n.)* hard-boiled eggs wrapped in sausage and bread crumbs and deep-fried.

**Scouse**, *(n.)* person from Liverpool.

**scraggy**, *(adj.)* scrawny. *That's another thing gets me down, this strange power I have over scraggy old birds!*

**scran**, *(n.)* food. *Now you tell me, after I've already taken all the scran over to the Queen Vic.*

**scrumpy**, *(n.)* alcoholic cider.

**scurf**, *(n.)* dandruff.

**scullery**, *(n.)* washroom off the kitchen; utility room.

**scupper it!**, *(v.)* stop it! *Scupper it! That noise is enough to wake the dead!*

**send to Coventry**, *(v.)* ignore a person.

**shandy**, *(n.)* beer with lemonade.

**shepherd's pie**, *(n.)* minced lamb with mashed potatoes and onions.

**shirty**, *(adj.)* smart-alecky. *She got shirty with a bloke from the council a couple of days ago.*

**shop soiled**, *(adj.)* sloppy; dirty. *Younger women have this crummy modern fashion of looking shop soiled.*

**shop**, *(v.)* turn in; betray. *So help me, I'll shop you if it comes down to it.*

**shufti**, *(n.)* look. *I've already had a shufti 'round his lodgings, and he's not there.*

**shut it**, *(v.)* shut up. Also **shut your teeth**. *"We're here. Shut it!" He meant my mouth, so I did.*

**skew whiff**, *(adj.)* askew; dilapidated; badly made. *The sign was skew-whiff as if it had been done by a school leaver for a quid.*

**skint**, *(adj.)* poor; broke. *Could you cover the price of a pastie, love. I'm a bit skint.*

**skive**, *(v.)* shirk. *What you been doing, skiving? This job should have been done by now!*

**sky off**, *(v.)* take off.

**slag**, *(n.)* slut; lowlife.

**slang-match**, *(n.)* verbal argument; *(v.)* to argue. *We slang-matched abuse for another minute before going over the payment.*

**slewed**, *(adj.)* thrown; dropped.

**slog**, *(v.)* go hard at anything. *Fearless Frank was slogging his way through chips, sardines and toast.*

**smarmy**, *(adj.)* toadying; insincerely flattering. *There came that blonde bird again, the smarmy creep, and Lucy doing her lipstick thing.*

**smashing**, *(adj.)* great; wonderful. *That's smashing. I'm proud of you.*

**the Smoke**, *(n.)* London. *I just know I'd get so low, away from the Smoke, that I couldn't make a go of anything. I'd get homesick.*

**smushed**, *(adj.)* drunken.

**snaps**, *(n.)* snapshots; photographs.

**snidey**, *(adj.)* snide; sarcastic. *Serves you right, snidey sod. Going to hide down here and bubble me, were you?*

**snog**, *(v.)* make out. *I told them I'd been snogging in a layby when that happened.*

**snout**, *(n.)* tobacco (originally a jail term).

**sod**, *(v.)* screw. *Sod the poxy boozer!*

**sosh**, *(n.)* social security. *I've only got my sosh and the pittance me boss pays me.*

**spanner**, *(n.)* wrench.

**speedo**, *(n.)* speedometer.

**spot on**, *(adj.)* exact(ly). *"Spot on," Lucy said, slapping a hand on the bar.*

**spotted Dick**, *(n.)* pudding with currants.

**sprog**, *(n.)* small child.

**squat**, *(n.)* empty or condemned building, used by homeless.

**stand one's corner**, *(v.)* pay one's share; pay for a round. *Lend me just enough to stand my corner.*

**starkers**, *(adj.)* naked.

**stick**, *(n.)* effort. *Give it some stick.*

**sticking plaster**, *(n.)* bandage.

**sticky wicket**, *(n.)* predicament.

**stone**, *(n.)* measure of weight, approximately 14 pounds. *I tried working out the measure; 14 pounds to a stone, say two herrings per pound...hopeless.*

**stop a-bed**, *(v.)* sleep late.

**storm in a teacup**, *(n.)* big deal over nothing.

**straight up**, *(adj.)* truthful; honest. *Are you tellin' it me straight up?*

**strides**, *(n.)* men's trousers.

**suss out**, *(v.)* find; find out. *It pays to suss out the rules governing the particular sale you wish to attend.*

**suspenders**, *(n.)* garters.

**swank about**, *(v.)* show off. *He was swanking about in his new whistle and flute.*

**swede**, *(n.)* mashed turnips

**sweet f.-a.**, *(n.)* absolutely nothing.

**Swiss roll**, *(n.)* jelly roll.

**swot**, *(v.)* study; cram.

# T

**ta**, *(excl.)* thanks.

**ta-ra**, *(excl.)* goodbye.

**Tannoy**, *(n.)* loudspeaker (trade name). *To make matters worse, the Tannoy croaked my name.*

**tarn**, *(n.)* lake.

**tartish**, *(adj.)* cheap-looking.

**tash**, *(n.)* mustache.

**tatty**, *(adj.)* ragged. *I've no carpet, only a couple of tatty rags I leap between like stepping stones.*

**tea cozy**, *(n.)* a knitted cover for a tea pot.

**tearaway**, *(n.)* thug; juvenile delinquent; unruly child. *Sykes is a bad lad. His lot's a right tribe of tearaways.*

**tec**, *(n.)* detective.

**teddy boy**, *(n.)* man of 'sixties-era style, with slicked-back hair, long-tailed coat, etc.

**telly**, *(n.)* television.

**telly advert**, *(n.)* commercial.

**telly licence**, *(n.)* licence paid once a year for the use of television; if unpaid one may be fined for using the television. *I used to watch telly, till some sadist among the authorities played hell about license money and nicked my black and white.*

**terraced house**, *(n.)* town house.

**thick as a plank**, *(adj.)* stupid. Also **thick as two short planks**.

**ticket tout**, *(n.)* scalper. *Our pal the ticket tout had to be nudged firmly on Tuesday night.*

**till girl**, *(n.)* cashier.

**tin**, *(n.)* can.

**tinned**, *(adj.)* canned.

**tip**, *(n.)* garbage dump. *Look to your own yard, it's a right tip.*

**titchie**, *(adj.)* small. *He was a titchie chap no taller than my elbow.*

**tipple**, *(v.)* drink (alcohol). *Have you been tippling again, Henry?*

**toad in the hole**, *(n.)* fried bread with an egg in the center.

**toff**, *(n.)* an uppercrust person.

**toffee-nosed**, *(n.)* stuck up.

**top**, *(v.)* kill. *Here, if you'd not been shagging that excise officer's missus, they'd be topping you.*

**torch**, *(n.)* flashlight.

**tout round**, *(v.)* ask around.

**townie**, *(n.)* city dweller. *The trouble with Ireland is the same with England; for a townie like me there's just too much countryside.*

**toys in the attic**, *(adj.)* crazy; barmy.

**trainers**, *(n.)* sports shoes; sneakers.

**tram, tramcar**, *(n.)* street car.

**trannie**, *(n.)* transistor radio. *A scruffy leather-clad yokel was at a workbench singing to a trannie.*

**transport caff**, *(n.)* truck stop.

**traps**, *(n.)* luggage; belongings.

**treacle**, *(n.)* molasses.

**trolley**, *(n.)* shopping cart; stroller.

**trundle**, *(v.)* go; move. *As we trundled past, somebody shouted my name.*

**tube**, *(n.)* subway.

**tuck shop**, *(n.)* sweet shop; cafe.

**turf**, *(v.)* turn in to the authorities.

**turf accountant**, *(n.)* bookie. *Her book shop was right next to the local turf accountants.*

**twig**, *(v.)* find out. *He was sore that I'd twigged it early on.*

**twin set**, *(n.)* short-sleeved sweater with a cardigan over the top.

**two up/two down**, *(n.)* terraced house with living room and kitchen downstairs and two bedrooms upstairs.

# U, V

**under the cosh**, *(adj.)* drunken.

**underground**, *(n.)* subway.

**up and downer**, *(n.)* fight. *They was having a right row, a real up and downer.*

**up the spout**, *(adj.)* up the creek; in trouble. *When we lost poor old Ollie's place, I thought we were up the spout.*

**V.A.T**, *(n.)* value added tax, added to prices on merchandise, not added at the register.

**vannie**, *(n.)* moving man. *It looked like Keven, least reliable of our vannies, but in the darkness you couldn't be sure.*

**vegan**, *(n.)* vegetarian.

**vicar**, *(n.)* minister.

# W

**wag it**, *(v.)* play hooky.
**wag**, *(n.)* gossiper. *We had enough wags in the village, thank you.*
**waistcoat**, *(n.)* vest.
**wallah**, *(n.)* self-important person.

**wally**, *(n.)* idiot; fool. *You made him look a ruddy wally, so now he'll seethe about it until he gets even.*

**warrant card**, *(n.)* policeman's identification. *Let's see your warrant card first, dearie, or I ain't openin' me door.*

**Weetabix**, *(n.)* breakfast cereal; wheat squares (trade name).

**wellingtons**, **wellies**, *(n.)* rubber boots.

**wetting tea**, *(v.)* steep tea.

**whacking**, *(adj.)* very; large; much. *He had a whacking great dog with him of indeterminate breed.*

**wheel**, *(n.)* big shot; VIP. *John always gave the impression he was a wheel.*

**wheel-a-bin**, *(n.)* garbage can on wheels.

**wheelie**, *(n.)* shopping cart.

**whiff of the fish monger**, *(n.)* seems wrong; smells fishy. *What kind of business is that, I ask you? It has a strong whiff of the fishmonger, I'd say.*

**whip round**, *(n.)* collection of money.

**whiskey muscles**, *(n.)* false courage.

**wicket**, *(n.)* gate.

**wide boy**, *(n.)* person not above petty crime; slightly crooked person. *They was a real bunch of wide boys, those Mitchells.*

**wind and water**, *(n.)* hot air. *The councilman was as full of wind and water as any politician I had ever seen.*

**wind up**, *(v.)* get a person going; make angry or annoyed. *Come on, now, don't wind me up.*

**wings**, *(n.)* fenders of an automobile.

**wipe**, *(n.)* handkerchief.

**wonky**, *(adj.)* wobbly; broken. *The damned push chair had a wonky wheel.*

**Woolie's**, *(n.)* Woolworth's (department store).

**wotcher**, a greeting. *Wotcher, Mick, how's business?*

**W.P.C.**, *(n.)* woman police constable.

# Y, Z

**Yank**, *(n.)* American.

**yammer**, *(v.)* talk on and on.

**the Yard**, *(n.)* Scotland Yard.

**yob**, *(n.)* fool. *She was trying to equate this infant-toting yob with the dealer she had heard of.*

**yobo**, *(n.)* hooligan.

**yonks ago**, *(n.)* years ago. *How was I supposed to remember something that happened yonks ago?*

**zed**, *(n.)* the letter Z.